W9-ABC-770

Visual Arts & Science

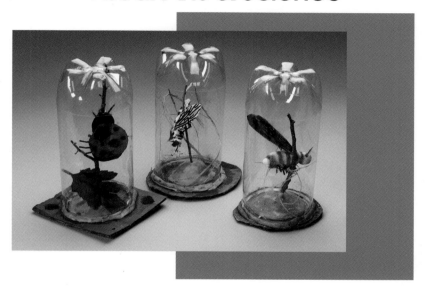

Dreams & Explorations

**Twelve Standards-Based Lessons
for Classroom and Art Teachers K-6**

15th Edition

BINNEY & SMITH A *Hallmark* Company

Easton, Pennsylvania

Credits

Front Cover: Photograph by Peter M. Sak. Student artwork by students from Madison Elementary School, Colorado Springs, Colorado. Art Teacher: Judy Curtis

Design
First Generation, Allentown, PA

Crayola, Dream-Makers, chevron, serpentine, Overwriters, Artista II, Classpack and Model Magic are registered trademarks; Smile design, Construction Paper, Premier, and Rocket Minds are trademarks of Binney & Smith.

Printed in the United States of America
ISBN: 0-86696-318-9

©2005, Binney & Smith, Easton, Pennsylvania, USA

Director of School and Organized Activities
Nancy DeBellis

For Crayola® Dream-Makers® 15, Dreams & Explorations:

Author and Managing Editor
Ron DeLong

Editors
Janet Brown McCracken
Donna Chastain

Photographer
Peter M. Sak

Editorial Assistance by
Tavy Thomas

For Crayola.com Dream-Makers Resources:
Jacqualyne M. Flynn

Binney & Smith gratefully acknowledges the teachers who tested the lessons in this guide:
Barbi Bailey-Smith, Little River Elementary School, Durham, North Carolina
Susan Bivona, Mont Prospect School, Clarksburg, New Jersey
Billie Capps, Little River Elementary School, Durham, North Carolina
Judi Collier, Little River Elementary School, Durham, North Carolina
Judy Curtis, Madison Elementary School, Colorado Springs, Colorado
Kay La Bella, Foothills Elementary School, Colorado Springs, Colorado
Elyse Martin, Jordan Community School, Chicago, Illinois
Rebecca Martin, Oakhurst Elementary School, Fort Worth, Texas
Patricia McKenna, Chamberlin Elementary School, Colorado Springs, Colorado
Nancy Rhoads, Curlew Springs Elementary School, Palm Harbor, Florida
Neila Steiner, C.S. 102, Bronx, New York
Erin Straight, Cabot Elementary School, Newton, Massachusetts
Bobbi Yancey, College Oaks Elementary School, Lake Charles, Louisiana
Ann Winters-Canfield, Bullard Talent School, Fresno, California

Additional thanks for their assistance and support to:
Mike Charles
Barbara Benton
Jill Jamison
Justin Knecht
Charles McAnall
Cheri Sterman
Elizabeth Willett
Michelle Wollman
Eric Zebley

Table of Contents

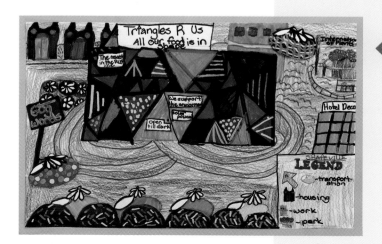

Artwork by students from
Mont Prospect School,
Clarksburg, New Jersey.
Teacher: Susan Bivona

The Crayola Dream-Makers Guide, *Dreams & Exploration, Visual Art and Science*, provides art and classroom teachers with twelve standards-based lessons that combine the study of visual arts with the study of science. It is our hope that art and classroom teachers will collaborate and use these lessons as springboards in their teaching to enhance student's knowledge and creative thinking.

Albert Einstein said, "The most beautiful thing we can experience is the mysterious. It is the source of all true art and all science." With this in mind, consider the commonality in the ways we think about, teach, and learn through visual arts and science.

Through the study of both academic disciplines, students observe, test, study experiment and verify. They quickly begin to understand there can be many answers or solutions to a single problem or assignment.

Recall for a moment the scientists that were challenged to create an air filtration system for the astronauts in Apollo 13. Their scientific knowledge combined with their ability to think outside the box allowed these creative problem-solvers to bring the astronauts safely back to Earth. Their skills to combine scientific fact and theory with creativity gave birth to a new solution that saved lives. This is one example of how thinking across the breadth and depth of academic disciplines can offer solutions to practical problems.

It very fitting that we combine the academic disciplines of both visual arts and science into this educational resources guide. The lessons are designed to inspire teachers to think about the mysteries, the beauty and joy that can be discovered when learning is accomplished through combining disciplines. For example:

- Encouraging children to classify leaves by similarities and differences in design may broaden children's understandings and their ability to observe and compare design in nature.
- As they explore oology, students investigate principles of design relationships commonly observed in eggs, and the animals that hatch from those eggs, to design newly created forms and designs.
- Assigning students activities that encourage them to observe insects in nature and then apply their knowledge to design a new species provides them with opportunities to extend their knowledge of the insect kingdom.

Artwork by students from Curlew Creek Elementary School, Palm Harbor, Florida. Teacher: Nancy Rhoads

All lessons in this guide have been teacher tested and offer assessment ideas that extend and measure learning. Additionally some lessons contain supportive fine art resources. Consider each lesson and modify and adjust the content to meet the needs of your specific population

As you apply the activities in this resource, you can help your students realize their dreams as they come to understand the most beautiful thing we can experience is "the mysterious," which is truly the source of all true art and all science.

– Ron DeLong

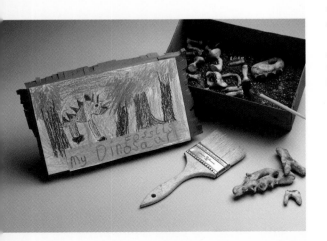

Collaboration Works!

Understanding that collaboration is a key to success in schools, we developed the lessons in this guide to encourage and support collaborative work. Although individual teachers can easily present lessons, we have broken out preparation steps and discussion starters to simplify teamwork and/or peer consultation. Of course, teachers benefit when tasks are shared, but students also benefit when they see more than one adult supporting their efforts.

Besides fellow art or classroom teachers, any of the following could have a place on your team: new teachers, reading specialists, librarians, parents, artists, art groups, and local art agencies.

Here are some steps for a successful team process. This can work whether you are jointly presenting a lesson over a few class periods or putting on a school- or community-wide exhibition.

1. First, share this guide with your collaborators before your first meeting, so they have an idea of what to expect.
2. Meet to agree on your goals and develop an action plan. Identify the steps you need to take and decide who will be responsible for each.
3. Make a calendar that includes the important milestones and allows adequate time for each process.
4. Work your plan. Have periodic meetings or phone calls to make sure you keep on track.
5. Don't forget to celebrate your success and recognize everyone who lent support. If you are presenting an exhibition, use the Dream-Makers "helpers" certificate (which you can download from Crayola.com/dreammakers) or make your own.
6. Assess results. What are your "lessons learned"?

Planning Your Own Exhibition

Publicly exhibiting their art is one of the most exciting and rewarding gifts you can give your students. Having an exhibition opening is a wonderful way to engage the school, parents, and community, especially if members of different groups help plan and put on the event. Here are some suggestions for a successful experience:

- Always display *all* students' work that was generated by the Dream-Makers activities.
- Exhibit artwork in a way that honors the students.
- Matting the artwork can be simple and inexpensive. For ideas on mounting and exhibiting artwork, go to Crayola.com/successguide, and click on the Art Teacher Guide.
- Consider displaying the student's dream statements along with the work. These can be especially compelling for adults viewing the work.
- You can demonstrate the value of your program by displaying the standards the lesson addressed with the artwork.
- If you select art to submit to the national program, develop selection criteria based on your school's or district's guidelines for assessment.

For your opening, enlist the help of parents and local businesses. Serve child-friendly refreshments and have a simple ceremony/photo op for presenting certificates of recognition to students and helpers. Invite district and community leaders so you can showcase their support.

YOUR COMMUNITY: Bridges Toward Creative Collaboration, a Crayola® "Strategies for Success" Guide

As advocates for the arts, we've worked with many community organizations, large and small, across the country. Over the years we've found that some are more successful than others at sustaining community support and engagement. One of the best we've known is the Kennedy Center Imagination Celebration (KCIC) in Colorado Springs, Colorado. We recently asked them to share their experience in using the arts to engage people to build and sustain a creative community. The result is a twelve-page guide to thinking big, starting small, and working collaboratively toward cultural connections. Topics covered include:

- Create a team with vision and mission
- Construct a strategic plan
- Identify resources in your community
- Build relationships and support collaborations
- Create vibrant, inclusive, and economically sound events
- Recognize and celebrate collaborators
- Sustain your success

For more information, including a free downloadable pdf, go to Crayola.com/successguide and click on the Community Success Guide.

About Crayola®
Dream-Makers®

Science in Art History

Historically, scientists have used visual art as a tool to help them record and communicate observations. In astronomy, for instance, we can see prehistoric drawings of the cycles of the moon, Galileo's sketches of Saturn as seen through his telescope, and stunning deep-space images captured by the Hubble Space Telsecope. Visual records and representations continue to be an integral part of our evolving understanding of the universe. Medical history also would not be the same without visual representation. Early diagrams of body systems preceded more detailed and accurate depictions of dissected cadavers, as seen in the work of Leonardo da Vinci.

To this day, illustrations by artists who specialize in medical images are often more useful for education than photography or medical scans, because an artist can emphasize areas or depict multiple layers in ways that are easier to understand. A more exotic modern example of the importance of visual art to science is fractals, which are mathematical relationships that are difficult to understand until they are visually created. Some scientific images have even been prized for their aesthetic value, which can be profoundly moving, even as they are objective records of observations.

Crayola Dream-Makers is a national program that encourages the creative development and learning of children in Kindergarden through 6th grade, recognizes student artists, and displays children's artwork in a national exhibition. Since 1984, millions of students and thousands of art and classroom teachers have participated in the program. Dream-Makers has been recognized by the U.S. Department of Education, the John F. Kennedy Center for the Performing Arts, the National Association of Elementary School Principals, the Association of Children's Museums, the National Art Education Association, and other leading arts and education organizations.

Since its inception, the program has collected 3,300 works of art by children, which are professionally framed and matted, documented, used as teaching tools, and exhibited to advocate art education. A large part of the collection decorates the offices of the U.S Department of Education in Washington, D.C. To view children's artwork from past years of the program, log on to Crayola.com/dreammakers and visit the Gallery of Children's Art.

Artwork by students from College Oaks Elementary School, Lake Charles, Louisana.
Teacher: Bobbi Yancey

Mastering Science Concepts Through Visual Art

An additional benefit to the Dream-Makers approach is the pleasure that children get from demonstrating mastery in a visual or tactile way. This is confirmed by art teacher Bobbi Yancey from College Oaks Elementary School in Lake Charles, Louisiana, who commented about the lesson *How Do Shadows Move in Space?* Bobbi says, "As an instructor I found the drawing a challenge for my students. I was unsure of what the final outcome would look like. The abstraction really pushed the students into a new direction, experimenting with shapes and shadows. The venture into creating an abstract work of art is a journey toward an "unknown" outcome...that is similar to our venture in space."

Funding Your Program

Ways of Funding a Dream-Makers Program

Funding your program is always a challenge. The process of prospecting for funds is grounded in the conviction that a partnership should develop between the community seeking funds and the organization that provides the funds. Dollars have no value until they are attached to solid programs. Bringing organizations together effectively can result in dynamic collaborations.

Funding takes time and persistence, and a good solution is to follow a step-by-step process in the search for dollars to fund your project or your program in your community.

Raising funds is definitely an investment in the future of your program, your school and your community. Your aim should be to build a network of organizations that can help on a steady basis.

The recommended process is not a formula to be adhered to rigidly. We suggest that you approach the process keeping in mind the specific needs of your program, your school, and your community. Always be creative and remember the words of educational guru Madeline Hunter, "Modify and adjust."

Gather Your Proposal Information

Your proposal will require documentation in three areas: concept, program, and expenses.

Pull together a team to help gather information. The data gathering process makes the actual writing much easier. Involving others in the project helps others understand the value of the project to your organization.

Adopt a Compelling Concept

Make sure the project fits into the mission and the philosophy of your organization. Funders want to know that a project reinforces the overall direction of an organization, and they may need to be convinced that the case for the project is compelling.

Detail Your Program

When making requests, consider the information that potential sponsors will need:
- The nature of the program and how it will be conducted
- The timetable for the program
- The anticipated outcomes and how best to evaluate the results
- Staffing and volunteer needs

Detail Expenses

Don't pin down all the expenses connected to the project until the program details and timing have been worked out. Financial gathering takes place after the narrative part of the master proposal has been written. Consider maintaining outlines of needs at this point.

Components of a Proposal

Executive Summary: Umbrella statement of your case and summary of the entire proposal – 1 page

Statement of Need: Why this project is necessary – 2 pages

Project Description: Nuts and bolts of how the project will be implemented and evaluated – 3 pages

Budget: Financial description of the project plus explanatory notes – 1 page

Organization Information: History and governing structure of the nonprofit; its primary activities, audiences, and services – 1 page

Conclusion: Summary of the proposal's main points – 2 paragraphs

For more information about grants and grant writing visit *The Foundation Center* at www.fdncenter.org.

Dream-Makers on the Web

Crayola.com/dreammakers includes extensive supplementary material for the program and the guide. Features include:

- Additional material for each lesson – extensions, adaptations, content webs, and links to resources

- Content from past Dream-Makers guides

- Printable certificates for recognizing children's participation and adults' support

- Thousands of images of children's Dream-Makers art from the last 20 years

- How to order guides

- And much more!

Your district Curriculum Coordinator or Supervisor can help you align lessons in the guide with your school's educational goals.

National Visual Arts Standards

Below are Content Standards from the voluntary National Visual Arts Standards, and a brief synopsis of the corresponding Achievement Standards. Although many educators are well acquainted with these, they are included here for easy reference. While these standards have not been adopted in full by each state, most state standards correspond with or are based on National Standards.

For information about the complete standards book, which includes a useful introduction and rationale for each age group, call the National Art Education Association at 1-800-299-8321, or visit their website at www.naea-reston.org.

Content Standards	Achievement Standards Synopsis for Grades K-4 & 5-8	
1. Understanding and applying media, techniques, and processes	In K-4, students recognize various materials, techniques and processes, and can describe and use these to communicate ideas, experiences, and stories, and to elicit viewer response. In K-8, students use materials and tools safely.	In 5-8, students select media, techniques and processes to enhance communication, then analyze whether or not these choices were effective, and reflect on the reasons.
2. Using knowledge of structures and functions	In K-4, students recognize different ways visual characteristics, expressive features and organizational principles communicate ideas and elicit different responses.	In 5-8, students generalize about the effects of visual structures and functions of art, use these to improve their own work's communication potential, and reflect upon whether or not these uses were effective.
3. Choosing and evaluating a range of subject matter, symbols and ideas	In K-4, students explore and understand prospective content for their art, then select and use appropriate subjects, symbols and ideas to make art meaningful.	In 5-8, students integrate concepts with content to communicate intended meaning as they work, using subjects, themes, and symbols that demonstrate knowledge of their work's contexts, values and aesthetics.
4. Understanding the visual arts in relation to history and cultures	In K-4, students understand that visual arts and specific artworks have a history and identifiable relationship to various cultures, times and places, and that time, place, culture and art influence each other.	In 5-8, students identify, describe, and compare characteristics of select artworks from various eras and cultures; identify the works' places along a cultural timeline; relate how time/place influence a work's visual characteristics.
5. Reflecting upon and assessing the characteristics and merits of their work and the work of others	In K-4, students understand/ describe purposes for creating artworks, how people's experiences influence a work, how various viewers' responses to one work differ.	In 5-8, students compare purposes for creating works; analyze a specific work's meaning by reviewing its history/culture; describe and compare responses to their own artworks and responses to works of other eras/cultures.
6. Making connections between visual arts and other disciplines	In K-4, students understand/use similarities and differences between visual arts and other arts disciplines. They find connections between visual arts and other subjects.	In 5-8, students compare characteristics of works in two or more art forms that share similar subject matter, eras, or cultural context. They describe the interrelationships between art and the principles/subject matter of other disciplines.

To learn more about art education's impact on children's development and learning, the Arts Education Partnership has published the following resources:

- *Critical Links: Learning in the Arts and Student Academic and Social Development (2002)*. This compendium summarizes and discusses 62 research studies that examine the effects of arts learning on students' social and academic skills.
- *Champions of Change: The Impact of the Arts on Learning (1999)*. This report compiles seven major studies that provide evidence of enhanced learning and achievement when students are involved in a variety of arts experiences.

These resources are available on the Arts Education Partnership's website at www.aep-arts.org.

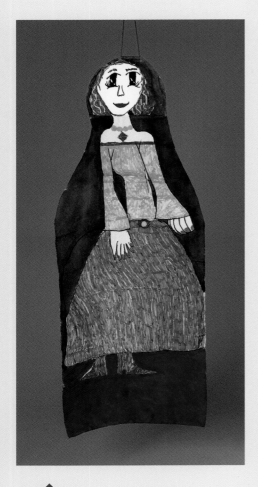

Artwork by students from Foothills Elementary School, Colorado Springs, Colorado. Teacher: Kay La Bella

National Science Standards

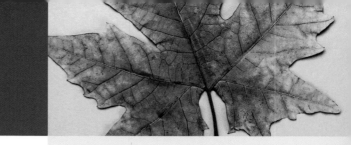

	Grades K-4	Grades 5-8
Unifying Concepts and Processes K-12	Systems, order, and organization Evidence, models, and explanations Change, constancy, and measurement Evolution and equilibrium Form and function	Systems, order, and organization Evidence, models, and explanations Change, constancy, and measurement Evolution and equilibrium Form and function
Science as Inquiry Standard	Abilities necessary to do scientific inquiry Understanding about scientific inquiry	Abilities necessary to do scientific inquiry Understanding about scientific inquiry
Physical Science	Properties of objects and materials Position and motion of objects Light, heat, electricity, and magnetism	Properties and changes of properties in matter Motions and forces Transfer of energy
Life Science	Characteristics of organisms Life cycles of organisms Organisms and environments	Structure and function of living systems Reproduction and heredity Regulations and behavior Populations and ecosystems Diversity and adaptations of organisms
Earth and Space Science	Properties of earth materials Objects in the sky Changes in earth and sky	Structure of the earth system Earth's history Earth in the solar system
Science and Technology	Abilities of technological design Understandings about science and technology Abilities to distinguish between natural objects and objects made by humans	Abilities of technological design Understanding about science and technology
Science in Personal and Social Perspectives	Personal health Characteristics and changes in populations Types of resources Changes in environments Science and technology in local challenges	Personal health Populations, resources, and environments Natural hazards Risk and benefits Science and technology in society
History and Nature of Science	Science as a human endeavor	Science as a human endeavor Nature of science History of science

Reprinted with permission from (National Science Education Standards)
© 1996 by the National Academy of Sciences, courtesy of the National
Academies Press, Washington, D.C.

Whose Bones Identify Terrible Lizards?

Grade Level
K-2

Classroom Time
One or two 40-min. periods

Materials/Tools
- Aquarium gravel
- Crayola® Blunt-tip Scissors
- Crayola Crayons Classpack®
- Crayola Glitter Glue Classpack
- Crayola Model Magic® Classpack
- Crayola Paint Brushes
- Crayola School Glue
- Crayola Watercolors
- Paper towels
- Plastic coffee stirrers
- Plastic dinner utensils
- Recycled newspaper
- Recycled shoe boxes with lids
- Water containers
- White drawing paper

Tips
Post a note asking volunteer parents, support staff, and colleagues to donate recycled shoe boxes with lids so each student can make a Dinosaur Dig Box.
Cover painting area with newspaper.

Resources
Creation by Gerald McDermott
Dinosaur Bones by Bob Barner
Dinosaur Dream by Dennis Nolan

Visual Arts Standard 2
Understanding the visual arts in relation to history and culture.

Science Content Standard
History and Nature in Science
Science as a human endeavor

Unifying Concept & Process–Science As Inquiry
Change, constancy, and measurement
Understanding scientific inquiry

Objective
Students study and then create fossil-like dinosaur forms to bury inside a Paleontologist Dinosaur Dig Box. Students draw dinosaur illustrations to match their forms to reveal the dinosaur species they selected.

Teacher Preparation
Classroom Teacher: Research and collect photographs depicting dinosaur dig sites. Show unearthed fossils from various locations around the world, such as China and Patagonia. Create a bulletin board displaying photos of digs and a world map that pinpoints dig sites. Use the resource as a class discussion starter.

Art Teacher: Make a sample Paleontologist Dinosaur Dig Box. Create several Model Magic examples of bone-like forms that are reflective of skeletal structures. Bury the bones in aquarium gravel in the box. Make drawings of dinosaur body parts that the skeletal forms represent. Display the samples.

Discussion Starters
Classroom Teacher: Ask students what the word *dinosaur* means (terrible lizard). Talk about why dinosaurs or lizards were terrible. Ask students to explain their knowledge about evidence that dinosaurs lived on Earth. Talk about students' knowledge of fossils. Discuss why people who look for dinosaur fossils are called paleontologists. Identify fossil dig sites on maps.

Art Teacher: Question the class about their knowledge of dinosaurs, fossil dig sites, and paleontologists. Prompt students to talk about how bones look and are formed. Talk about how particular bones make it possible to identify animal body parts. Show the Paleontologist Dinosaur Dig Box. Invite students to use plastic spoons and brushes to excavate the contents of the sample box. Ask students to create their own boxes. Provide studio time for students to create their own animal drawings or dinosaur fossil forms.

Process
1. Shape half of a one-ounce package of Model Magic into a leg-like fossil model.
2. Roll half of the remaining modeling compound into a long cylinder. Cut it into 1" lengths. Tap the ends of these small cylinders to create vertebrae forms. Connect "vertebrae" by inserting pieces of plastic coffee stirrers into the ends of the forms.
3. Roll spheres of Model Magic and model them into skulls, hipbones, and other dinosaur-like skeletal forms. Texture them with plastic dinner utensils. Air-dry overnight.
4. Paint the models with watercolors if desired. Air-dry the paint.
5. Bury fossil forms inside a Dinosaur Dig Box (take turns or use individual boxes). Unearth forms with plastic spoons and brushes.
6. With crayons and paper, create a drawing of a dinosaur that matches the bone replicas.

Assessment
Students summarize their learning. They exchange and examine drawings and fossil-like forms to analyze how well they match.

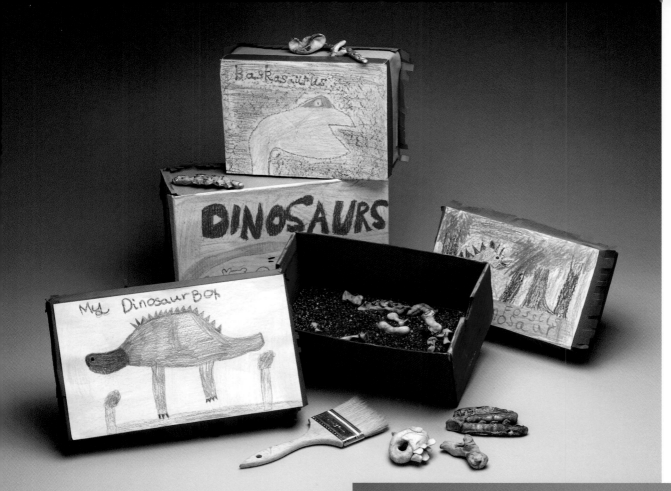

Artwork by students from Curlew Creek Elementary School, Palm Harbor, Florida.
Teacher: Nancy Rhoads

Background Information

Scientists put together dinosaur bones like a puzzle. They use chisels, diamond saws, and dental drills to remove bones from rock. Bones (fossils) are the organic remains of prehistoric plants and animals. They also are the records of ancient life on our planet. Fossils help us understand living things today, providing clues to their adaptations and behaviors.

Argentina, particularly Argentinian Patagonia, is a very good place for paleontologists to look for dinosaurs. The biggest dinosaur fossil, *Giganotosaurus Carolinii,* and many dinosaur footprints are located in a lake area in this part of the world.

What Clues Do Leaves Leave Behind?

Grade Level
K-2

Classroom Time
One or two 40-min. periods

Materials/Tools
- Construction paper
- Crayola® Construction Paper™ Crayons Classpack®
- Crayola School Glue
- Crayola Scissors
- Glycerin
- Leaves
- Magnifying glass
- Paper towels
- Recycled box
- Recycled newspaper
- Water container

Tip
Request parent volunteers to help soften real leaves for use in class. Follow "Preparing Leaves" in the process for directions. Cover the work area with newspaper.

Resources
Autumn Leaves by Ken Robbins
Leaves: Itty Bitty Nature Books by F.S. Matthews
Why Do Leaves Change Color by Betsy Maestro

Visual Arts Standard 3
Choosing and evaluating a range of subject matter, symbols, and ideas.

Science Content Standard
Physical Science
Properties of objects and materials

Unifying Concept & Process–Science As Inquiry
Systems, order, and organization
Understanding scientific inquiry

Objective
Students create a crayon rubbing with leaves found in their community. They classify leaves by similarities and differences in design, which reflects their abilities to understand, observe, and compare.

Teacher Preparation
Classroom Teacher: Go on a class nature hike, if possible, to collect fallen leaves. Collaborate with the art teacher to create a Leaf Box that contains a wide variety of soft leaves. Label and display samples of leaves.

Art Teacher: Research and collect drawings, photographs, and paintings that illustrate properties of leaves. Prepare and display technique boards to show how to create a leaf rubbing. Share the boards with the classroom teacher for discussions.

Discussion Starters
Classroom Teacher: Ask students to take a leaf from the Leaf Box. "Who has looked at a leaf closely? How do leaves look different? How are they the same?" Children list leaf similarities and differences.

Art Teacher: "What have you learned about leaf shapes? How are they the same and different? Take a closer look at leaves to see different kinds of lines, shapes, and textures." Invite students to make leaf rubbings.

Process
Preparing Leaves
1. Dry, brittle leaves are hard to work with. Soften leaves by immersing them in a solution of 2 parts water and 1 part glycerin (found in drug store cosmetic sections or craft store cake decorating areas).
2. Layer the leaves in a shallow pan. Cover with glycerin solution. Soak for 24 hours.
3. Remove, pat dry with paper towels, and press between newspaper or recycled telephone books for 3 days. The colors will not be as bright as they were when they were collected, but the leaves will be soft and pliable.

Creating Leaf Rubbings
1. Peel off wrappers from several colors of crayons.
2. Lay down several soft leaves.
3. Place colored construction paper on top of the leaves.
4. Press the unwrapped side of a crayon on the construction paper. Pull the crayon barrel across the surface to reveal the leaf designs. Press the barrel firmly against the paper for best results.
5. Move the leaf or paper if desired to create a ghosting effect during the rubbing process.
6. Make additional rubbings with various leaves to extend the design possibilities.
7. Cut out the leaf shapes. Glue them on to another paper to create a leaf collage.

Assessment
Students summarize their learning by classifying leaf designs using similarities and differences observed in their art.

Artwork by students from
Cabot Elementary School,
Newton,
Massachusetts.
Teacher: Erin Straight

Background Information

The variety of plant leaves is enormous. There are large leaves, small leaves, slender leaves, and wide ones. Leaves can be soft, prickly, hairy, and hard. All leaves have one thing in common: they change sunlight into energy through photosynthesis. They absorb carbon dioxide from the air. Leaves combine the carbon dioxide with water (that comes up through the roots of the plant) to release oxygen into the air. By doing this exchange, plants help keep oxygen in the air that benefits all living things.

What Is at the End of Your Rainbow?

Grade Level
K-2

Classroom Time
One or two 40-min. periods

Materials/Tools
- Crayola® Paint Brushes
- Crayola Crayon Classpack®
- Crayola Washable Markers Classpack
- Crayola Watercolors
- Paper towels
- Recycled newspaper
- Water containers
- White drawing paper

Tip
Cover the painting area with newspaper.

Resources
Planting a Rainbow by Lois Ehlert
The Rainbow Fish by Marcus Pfister

Objective
Students observe rainbows and then create watercolor paintings that both reflect a rainbow color sequence and show what they imagine might be at a rainbow's end.

Teacher Preparation
Classroom Teacher: Research, collect, and mount a display of settings that depict rainbows. Title the display *What Is at the End of Your Rainbow?* Ask students to make a word list of things that they dream of finding at the end of a rainbow. Study rainbows (see Background Information). Help the art teacher create an engaging rainbow pathway display.

Art Teacher: Mount a ribbon of rainbow colors along the hallway from the classroom to the art room. Design the ribbon pathway so that the rainbow ends at a large, 3-D, closeable container with a "?" in bold glow lines so children will wonder about the container's contents. Fill the container with items that inspire children to think of magical things they may want to illustrate in their rainbow art.

Discussion Starters
Classroom Teacher: Ask students what rainbows have in common. "How are rainbows formed? What colors are found in a rainbow?"

Art Teacher: "Did you ever hear the expression *'look for a pot of gold at the end of a rainbow?'* Has anyone ever walked inside the end of a rainbow? Imagine what you might find there." Demonstrate painting techniques that keep colors bright, not muddy. Ask children to think about and then create a rainbow painting. Have them visualize magical, imaginative things that they wish they could find at the rainbow's end.

Process
1. Brush clean water over the paper. Load the brush with the first color that appears in a rainbow sequence and apply paint to paper.
2. Rinse the brush thoroughly and blot on a paper towel. Load and apply the next color in the rainbow sequence. Continue until the rainbow color sequence is complete. Limit brushing on wet painted areas. Wet colors bleed and blend at edges naturally for fantasy-like effects. Air-dry the painting.
3. Draw imaginative objects at the rainbow's end with washable markers and crayons. Summarize learning.

Assessment
Display all student illustrations. Ask students to identify drawings that accurately depict the sequence of rainbow colors. All students describe orally or in writing the objects they illustrated at the end of their rainbows.

Visual Arts Standard 6
Making connections between visual arts and other disciplines.

Science Content Standard
Earth and Space Science
Changes in Earth and sky

Unifying Concept & Process–Science As Inquiry
Change, constancy, and measurement
Understanding scientific inquiry

Artwork by students from Oakhurst
Elementary School, Fort Worth, Texas.
Teacher: Rebecca Martin

Background Information

A rainbow is sunlight spread out into its spectrum of colors and diverted to the observer's eye by water droplets. The sun is behind you when you see a rainbow in the sky. According to Richard Whelan, "Among the conditions necessary in order for a rainbow to occur, the most essential are, first, rain falling in the direction toward which the observer is facing and, second, bright sunlight coming from a relatively low point along the horizon behind the observer."

The "bow" part of the word describes the fact that the rainbow is a group of nearly circular arcs of color, all of which have a common center. Rainbows are made of seven colors (from the outside in)—red, orange, yellow, green, blue, indigo, and violet. Actually, rainbows are a continuum of colors including some that human eyes cannot see.

The rainbow is a symbol of hope and peace in many cultures. Shakespeare, Rubens, Monet, Inness, and Church are among many artists throughout history who have included rainbows in their works.

Where Does the Tooth Fairy Take Lost Teeth?

Grade Level
K-2

Classroom Time
Two or three 40-min. periods

Materials/Tools
- Cotton string, colored yarn, or ribbon
- Crayola® Glitter Glue Classpack®
- Crayola Model Magic® Classpack
- Crayola Regular or Erasable Colored Pencils
- Crayola glue sticks
- Recycled boxes with lids
- White drawing paper

Tip
Ask colleagues, students, and parent volunteers to collect and save assorted lidded cardboard boxes.

Resources
Arthur Tricks the Tooth Fairy by Marc Brown
Dear Tooth Fairy by Alan Durant & Vanessa Cabban
How Many Teeth? by Paul Showers
What Do the Fairies Do With All Those Teeth? by Michael Luppens

Visual Arts Standard 1
Understanding and applying media, techniques, and processes.

Science Content Standard
Science in Personal & Social Perspectives
Personal health

Unifying Concept & Process–Science As Inquiry
Change, constancy, and measurement
Understanding scientific inquiry

Objective
Students create a tooth-like beaded bracelet that indicates the number of missing teeth observed in their mouths. They also decorate a Tooth Fairy Box with scenes that show where the tooth fairy takes their missing teeth.

Teacher Preparation
Classroom Teacher: Create a display to highlight good dental hygiene. Ask a dental health expert to talk with the class. Encourage children to describe their own personal dental hygiene practices and chart different approaches to good dental health. Make cards with glitter glue that contain words related to dental health on one side and definitions of the words on the reverse. Challenge students to learn terms and definitions.

Art Teacher: Research, collect, and display Victorian fairy painting reproductions by John Atkinson Grimshaw, Joseph Noel Paton, Richard Dadd, Richard Doyle, and E.R. Hughes to inspire thinking. Make a magic fairy wand (see Extension at crayola.com/dreammakers).

Discussion Starters
Classroom Teacher: Before reading *What Do the Fairies Do With All Those Teeth?* ask students what they think the tooth fairy does with the teeth that are collected. Explain to students that they have naturally been losing their first set of teeth (primary teeth), and that a second set of teeth is growing that must last their lifetime.

Art Teacher: Stimulate student thinking with a magic fairy wand. Call on students to complete the statement, "The tooth fairy lives in a place that looks like…." Ask students to write their responses on drawing paper.

Process
Create a Tooth Fairy Box
1. Trace around the box lid on paper. Label the lid with words such as "The Tooth Fairy."
2. Use colored pencils to draw scenes or settings that illustrate a place that the tooth fairy might hide lost teeth. Glue the illustration to the lid.

Create Beads
1. Tie and knot about 10" of ribbon, yarn, or string to create a bracelet. Count how many teeth were lost (or predict how many will be lost).
2. Roll one marble-size sphere of white Model Magic for each lost tooth.
3. Wrap the spheres around the bracelet and shape them like teeth. Add glitter glue for sparkle.
4. Air-dry the bracelet before placing it in the Tooth Fairy Box.

Assessment
Students exchange Tooth Fairy Boxes. They observe and check that the counts of teeth on the bracelets match the teeth observed in their mouths. Students describe sites where the tooth fairy hides teeth, based on clues illustrated on the Tooth Fairy Box. Summarize learning.

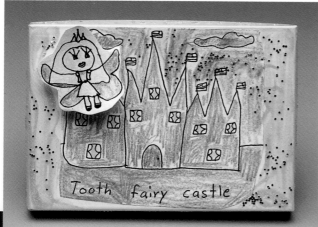

Artwork by students from Jordan Community School, Chicago, Illinois. Teacher: Elyse Martin

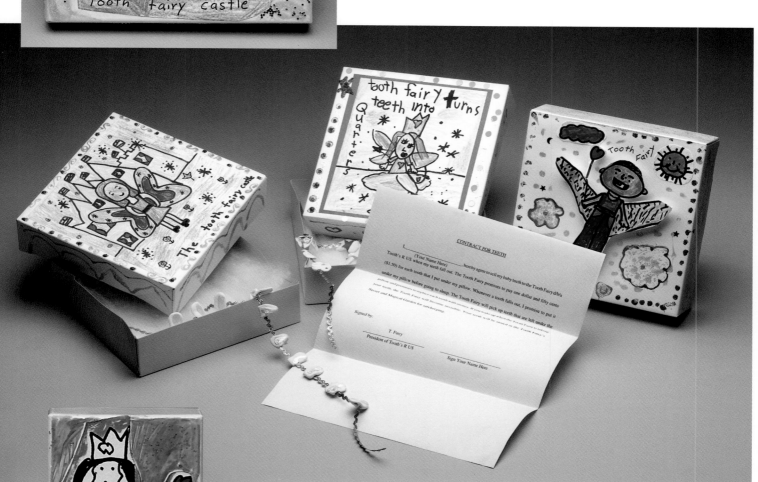

Background Information

The Golden Age of fairy painting occurred in 19th Century England during the reign of Queen Victoria. According to Terri Windling in *Victorian Fairy Painting*, "Folklore was a new and exciting area of scholarship, giving old country tales about spirits and fairies a caché they'd previously lacked." Interest in the "unseen" world was widespread throughout England during this time.

Artists continue to create magical, enchanting paintings depicting fairies in their environments. Many artists use British folklore as inspiration.

How Do Shadows Move in Space?

Grade Level
3-4

Classroom Time
Two or three 40-min. periods

Materials/Tools
- Crayola® Artista II® Tempera Paint
- Brown rolled craft paper
- Crayola Glitter Glue Classpack®
- Crayola Model Magic® Classpack
- Crayola Oil Pastel Classpack
- Crayola Paint Brushes (assorted sizes)
- Crayola School Glue
- Five 10-inch lengths of string or yarn per team
- Overhead projector (use with adult supervision)
- Paper clips
- Paper towels
- Recycled newspaper
- 12" – 15" sticks or tree branches found on the ground.
- Water container

Tips
Invite parent volunteers to help collect sticks for the mobiles. Apply glue to paper clip prior to deeply embedding clip into forms, and then allow the object to dry completely before assembling mobiles. Cover the painting area with newspaper.

Resources
Alexander Calder and His Magical Mobiles by Jean Lipman with Margaret Aspinwall
Destination Jupiter by Seymour Simon
Hand Shadows and More Hand Shadows by Henry Bursill

Visual Arts Standard 5
Reflecting upon and assessing the characteristics and merits of their work and the work of others.

Science Content Standard
Physical Science
Positions and motion of objects

Unifying Concept & Process–Science As Inquiry
Form and function
Abilities to do scientific inquiry

Objective
Students model and assemble a mobile that contains forms reflective of celestial bodies observed in space. They then create oil pastel shadow-motion drawings generated by the moving shadows of the forms.

Teacher Preparation
Classroom Teacher: Place cardboard on top of an overhead projector to keep children from seeing objects placed on the projector. Collect assorted objects and place them in a bag for use in making shadows. Prepare shadow cutouts from assorted objects and display them.

Art Teacher: Create two model solar system mobiles that illustrate the laws of weight and balance as applied to the creation of mobiles. Make one mobile to illustrate balance and one that is not balanced. Create a poster to illustrate steps in creating a balanced solar system mobile.

Discussion Starters
Classroom Teacher: Read *Alexander Calder and His Magical Mobiles* and show illustrations from *Hand Shadows and More Hand Shadows* to students. Discuss shadows and how they are made. Experiment with shapes and shadows created by a projector and assorted objects. Explain eclipses.

Art Teacher: Research, collect, and display NASA photos of celestial bodies with shadows cast upon them. Ask students if they think that astronauts are able to observe moving shadows in space. Create a workstation where students can hold their mobiles to cast shadows onto paper that is attached to a newspaper-covered floor easel, wall, or bulletin board.

Process
Create the Mobile
1. Show solar system photos. Demonstrate how to model simple celestial forms that are reflective of elements observed in the photos.
2. Break into teams of four or five students. Each group will need: three or four 1-ounce packs of white Model Magic, two different lengths of armatures such as sticks or wooden dowels, five 10" lengths of yarn or string, and four small paper clips.
3. Model solar system celestial bodies. Embed small, glue-covered paper clips deeply into the soft forms. Air-dry overnight. Paint the forms. Air-dry the paint.
4. Experiment with weight and balance, and work collaboratively to assemble mobiles. Apply glitter glue to decorate the forms and air-dry the glue.
5. Thread and then loosely tie the forms together on the stick armatures. Check that forms balance and move when the mobile is suspended. Modify and adjust string lengths until balance is achieved.

Draw Colorful Shadow Designs
1. Hold the mobile anchor string to suspend the mobile so forms cast shadows on the paper in the workstation.
2. Quickly trace shapes of moving shadows with oil pastels to create action-like shadow and movement drawings. Fill the action-like shape with oil pastel color.
3. Brush a thin tempera paint wash over the entire drawing. Air-dry the paint.
4. Reapply additional oil pastel color to dried work to extend design possibilities.

Assessment
Randomly display the mobiles and action-shadow drawings. Ask students to look at, study, and then analyze and match mobiles to the correct action-shadow drawings created from the mobiles.

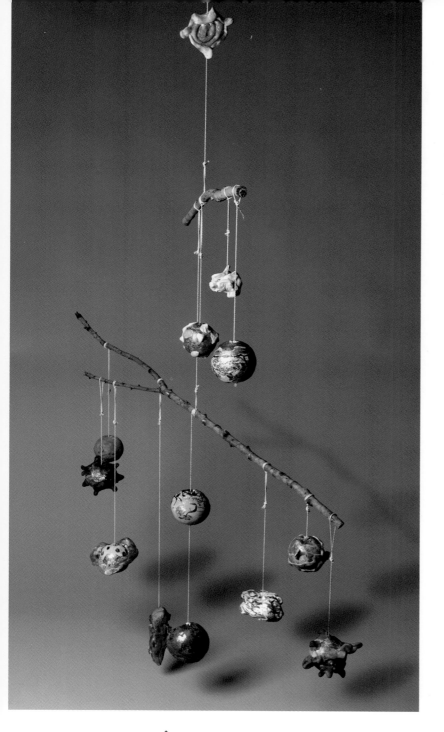

Artwork by students from College Oaks
Elementary School, Lake Charles, Louisana.
Teacher: Bobbi Yancey

Background Information

According to Seymour Simon in *Destination: Jupiter*, "No one has ever seen the surface of Jupiter. Clouds hundreds of miles thick cover the planet. We see only the tops of the clouds: bands of reds, oranges, tans, yellows, and whites."

The Earth, when observed from space, appears to many like a marble in motion. Its surface is covered with blues, browns, greens, white, and other Earth colors. When celestial bodies, block the light of the sun from reaching the Earth and other planets' surfaces, it casts shadows on the forms and changes the color as we typically see it. These shadow events are called eclipses.

How Will You Create a Phases-of-the-Moon Manga?

Grade Level
3-4

Classroom Time
Two or three 40-min. periods

Materials/Tools
- Crayola® Erasable or Regular Colored Pencils
- Crayola Overwriters® Markers
- Straight edges
- White drawing paper

Tip
Display Manga that are appropriate to understanding how the art is created. Modify and adjust product to activity as appropriate.

Resources
Learn How to Draw Manga–A Step-by-Step Guide by Emmett Elvin
Manga–Sixty Years of Japanese Comics by Paul Gravett
Papa, Please Get the Moon for Me by Eric Carle

Objective
Students create a Manga-like illustration that depicts a character in settings that accurately show the eight distinct illuminated phases of the moon.

Teacher Preparation
Classroom Teacher: Ask student volunteers to cut and display paper shapes of the eight phases of the moon. Make word cards that list the moon's phases. Visit Crayola.com/dreammakers for more information about moon phases.

Art Teacher: Research and create a display of Japanese Manga and U.S. comic illustrations. Display them side by side.

Discussion Starters
Classroom Teacher: "What is a *terminator*? Could a terminator be found on the moon? A terminator is the curved edge of the shadow on the moon as it creates the horns or pointed ends of the moon's crescent. The horns always face away from the setting or rising sun. They always point upward in the sky. Sometimes artists draw the horns of the moon incorrectly. Drawings of moons like this are called 'impossible moons.'"

Art Teacher: Who has ever read a comic book? In Japan, comics called *Manga* are considered an art. Some dictionaries identify Manga as Japanese comic books and cartoon films with a science fiction or fantasy theme. Look at the display of U.S. comic book art and Manga illustrations. Let's list what we see that is similar and different in these two types of art. Then you will create a Manga or cartoon illustration that shows a character in a setting looking at the phases of the moon.

Process
1. Fold a 12" by 18" sheet of white drawing paper into eight rectangles.
2. Highlight the folds with a dark Overwriters "under color" marker to distinguish rectangles from each other. Use a straight edge for accurate highlighting.
3. Write the sequence of the eight phases of the moon on the back of the paper using colored pencils.
4. Think of a nighttime story about a character that takes place during one month.
5. Sketch a Manga-like drawing inside each of the highlighted rectangles with Overwriters "under colors." Be sure that your story depicts the correct sequence of the phases of the moon. Include signs and symbols.
6. Use Overwriters "over colors" to enhance your illustrations with dramatic Manga-like drawing effects if possible.

Assessment
Students exchange Manga-like illustrations and check for accuracy. Summarize similarities and differences observed in the drawings.

Visual Arts Standard 4
Understanding the visual arts in relation to history and culture.

Science Content Standard
Science and Technology
Abilities of technological design

Unifying Concept & Process–Science As Inquiry
Form and Function
Properties and changes of properties in matter

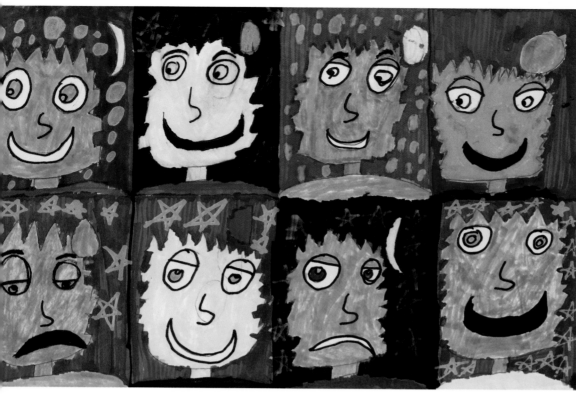

Artwork by students from Asa Packer Elementary School, Bethlehem, Pennsylvania. Teacher: Linda Kondikoff

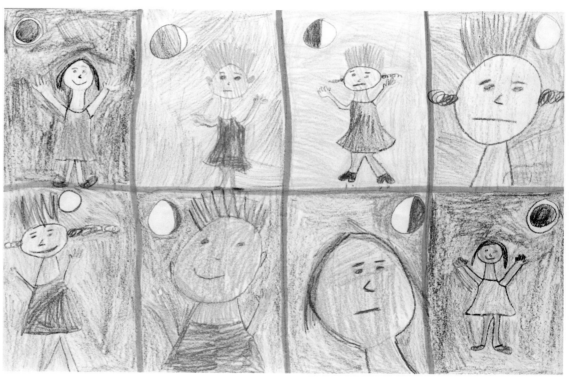

Artwork by students from Little River Elementary School, Durham, North Carolina. Teachers: Barbi Bailey-Smith; Judi Collier

Background Information

According to some experts, the phases of the moon are caused by the relative positions of the Earth, sun, and moon. The moon goes around the Earth, on average, in 27 days, 7 hours, and 43 minutes.

The sun always illuminates the half of the moon facing it (except during lunar eclipses, when the moon passes through the Earth's shadow). When the sun and moon are on opposite sides of the Earth, the moon appears "full" to us, a bright, round disk. When the moon is between the Earth and the sun, it appears dark, a "new" moon. In between, the moon's illuminated surface appears to grow (wax) to full and then decrease (wanes) to the next new moon.

The edge of the shadow (the terminator) is always curved, giving the moon its familiar crescent shape. Because the "horns" of the moon at the ends of the crescent are always facing away from the setting or rising sun, they always point upward in the sky. It is fun to watch for paintings and pictures that show an "impossible moon" with the horns pointed downwards.

How Does Oology Help Reveal What's Inside an Egg?

Grade Level
3-4

Classroom Time
Two or three 40-min. periods

Materials/Tools
- Crayola® Glitter Glue Classpack®
- Crayola Model Magic® Classpack
- Crayola Paint Brushes
- Crayola School Glue
- Crayola Watercolors
- Found objects
- Masking tape
- Modeling tools
- Paper towels
- Plastic coffee stirrers or plastic dinnerware
- Recycled newspaper
- Water container
- White watercolor paper

Tips
Ask parent or student volunteers to tape together a tightly crumpled tennis ball-size amount of newspaper as an egg to form armatures. Thoroughly wash any natural eggs that you will use for show and tell. Cover the painting area with newspaper.

Resources
Fabergé Eggs: A Book of Ornaments–The Forbes Magazine Collection by Ellen Rosefsky Cohen

Objective
Students investigate natural and decorative egg forms. Students decorate model eggs to match an imaginative companion illustration that depicts what might hatch from their eggs.

Teacher Preparation
Classroom Teacher: Research, collect, and display books that contain illustrations of birds and their eggs for students to study.

Art Teacher: Collect and display a wide variety of natural and decorative eggs. Include Ukrainian Pysanky Easter Eggs, reproduction Fabergé eggs, chicken eggs, duck eggs, and others (for display only). Thoroughly wash any natural eggs.

Discussion Starters
Classroom Teacher: Explain to students that sometimes the color, size, decoration, detail, shapes, and texture of an egg help us know what will eventually hatch from it. "Visual clues help us classify and categorize the organism that could develop inside the egg. Often external visual features help disguise the egg from predators. The study of eggs is called oology."

Art Teacher: Start a discussion about the differences observed between manufactured decorative eggs and natural eggs. Invite the students to use their imaginations to conjure up an egg and an illustration of a creature that would hatch from it, so that the two relate through color, shape, size, and texture.

Process
Create the Decorative Egg
1. Press Model Magic into a ¼-inch-thick flat slab. Wrap the slab around an egg-shaped newspaper armature. Gently shape and model it to create a form that illustrates a fanciful egg form.
2. Texture the form by impressing modeling tools such as plastic coffee stirrers or other objects into the surface. Air-dry the egg overnight.
3. Fill the egg surface with watercolor designs. Air-dry the painting. Cover the surface with a school glue. Air-dry the glue.
4. Embellish the egg form with glitter glue or found materials for dazzling effects. Air-dry the glue.

Draw the Creature
1. Study the egg you created. With watercolors, paint a creature that might hatch from the egg. Be sure to include characteristics that are reflected in the egg you created. Air-dry your painting.
2. Embellish your painting with glitter glue and found materials that you included on the egg form. Air-dry the glue.

Assessment
Summarize learning. Mix and then display egg forms and illustrations. Challenge students to match eggs to illustrations based on clues observed in both artworks.

Visual Arts Standard 1
Understanding media, techniques, and processes.

Science Content Standard
Life Science
Organisms and environments

Unifying Concept & Process–Science As Inquiry
Evidence, models, and explanations
Understanding scientific inquiry

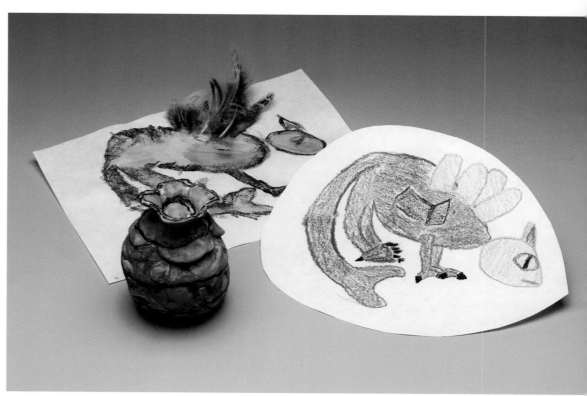

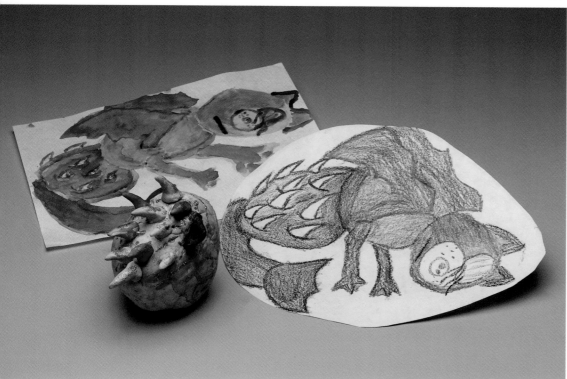

Artwork by students from
CS 102, Bronx, New York.
Teacher: Neila Steiner

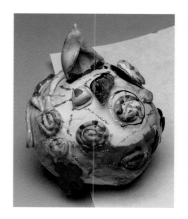

Background Information

The ostrich egg is the largest existing single cell currently known, although some dinosaur eggs were larger. The bee hummingbird produces the smallest known bird egg, which weighs half of a gram. Reptile eggs and most fish eggs are even smaller, and those of insects and other invertebrates are much smaller still.

People from every part of the world have used their imaginations to decorate eggs using all kinds of materials. Peter Carl Fabergé was an extraordinary artist who worked with artisans to make incredible fantasy eggs that have brought enduring fame to the House of Fabergé.

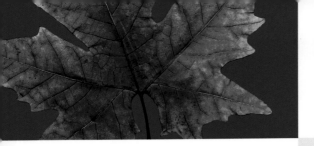

In What Direction Do "You" Usually Fly?

Grade Level
3-4

Classroom Time
Two or three 40-min. periods

Materials/Tools
- Clothesline and clothespins
- Crayola® Erasable Markers
- Crayola Fabric Markers
- Crayola School Glue
- Crayola Scissors
- Fabric panels
- Hole punch
- Oak tag
- Paper
- Yarn or string

Tips
Ask parent volunteers to recycle, measure, and cut apart clean cotton or 50/50 cotton/polyester bed sheets into various size panels and to cut yarn or string into 18" pieces.

Resources
Kites: Magic Wishes That Fly Up to the Sky by Demi
The Great Kite Book by Norman Schmidt
The Wing Shop by Elvira Woodruff

Visual Arts Standard 2
Reflecting upon and assessing the characteristics and merits of their work and the work of others.

Science Content Standard
History and Nature in Science
Science as a human endeavor

Unifying Concept & Process–Science As Inquiry
Physical Science
Change, constancy, and measurement

Objective
Students design, create, and fly a personalized "You" wind banner to gather baseline data on wind direction. They will chart, measure, and test the data they collect over time against their original hypotheses about the dominant direction that the wind blows.

Teacher Preparation
Classroom Teacher: Make a class wall chart with columns and rows titled *In What Direction Do "You" Usually Fly?* List students' names and their hypotheses about wind direction, one per row, in the left-hand column. Create columns for each calendar day the students will measure the direction their "You" banners fly (collect data for at least 2 weeks).

After the banners are made, hang a clothesline in a safe outdoor area where the wind blows freely. Assist children to hang their "You" banners on dry days only. Children observe and mark the chart with a wind direction letter: N = north, S = south, E = east, W = west. Combine directions where necessary such as NE and SE. Summarize and analyze the collected data.

Art Teacher: Research the brief history of weather vanes and then create a display featuring images of weather vanes. Create a banner that reflects your traits and characteristics.

Discussion Starters
Classroom Teacher: "Who knows how wind direction is determined? Weather vanes, windsocks, banners, and flags all can indicate the direction the wind blows. Weather vanes and windsocks are made so they freely rotate in a horizontal plane and can be used to measure the direction the wind is blowing." Ask children to enter their hypotheses on the classroom chart.

Art Teacher: "Japan and South Korea celebrate children's day. Some families make and display banners they fly in the wind to honor their children. Today we will create a 'You' banner that reflects your personality. Your 'You' banner will be used to help you chart and test your hypotheses about which direction the wind blows most often."

Process
1. Fold 9" by 12" oak tag into a 6" by 9" book. Measure and mark two dots with markers, one inch in from both ends, on the fold. Punch a hole through the tag at the dots. Thread yarn or string through the holes. Tie the ends closed.
2. Open the oak tag. Spread glue on both open ends, about 3" wide. Place a fabric panel on the glue. Fold the flap closed to sandwich the fabric between the glued areas, and press down.
3. Draw your head, with detailed facial features, on the oak tag using erasable markers. (The top of your head can be where the yarn is.) If you change your mind or make a mistake as you draw, just erase. Trim around your oak tag head, being careful not to disturb the yarn or string.
4. Draw your clothed torso, with arms and legs, on the fabric panel with fabric markers. Heat-treat the fabric using a heated iron so designs become permanent (adult supervision required).
5. On dry days only, fly the banner to track wind direction.

Assessment
Students share, compare, and check one another's recorded and summarized data about the direction the wind carried their "You" banners. Students note whether their hypotheses match the recorded data. Summarize learning.

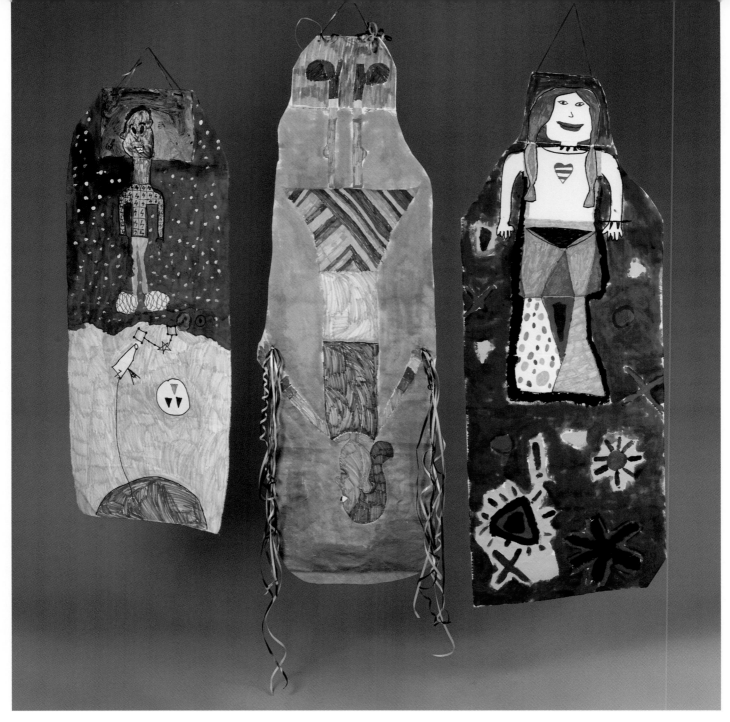

Artwork by students from
Foothills Elementary School, Colorado
Springs, Colorado.
Teacher: Kay La Bella

Background Information

 Flags and banners have been used around the world and throughout history to help scientists learn about wind flow directions and to add design and color to celebrations.

 Today, Japan celebrates Children's Day (Kodomo no hi) and flies banners on May 5. The Boy's Festival (Tango no Sekku), was traditionally celebrated on this day. Typically, banners are hand-painted and displayed in or around the home.

 The Hina Matsuri (Doll Festival or Girl's Festival) is celebrated in Japan on March 3. On this day, families with girls wish their daughters a successful and happy life. Banners are personalized with family crests called mons and the name of the child in konji is included in the design.

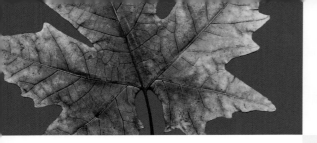

In What Biosphere Will Bugs Thrive?

Grade Level
5-6

Classroom Time
Two or three 40-min. periods

Materials/Tools
- Corrugated cardboard, cut in to shapes
- Crayola® Glitter Glue Classpack®
- Crayola Model Magic® Classpack
- Crayola Overwriters® Markers
- Crayola School Glue
- Crayola Scissors
- Crayola Watercolor Brushes
- Crayola Watercolors
- Magnifying glasses
- Modeling tools
- Natural materials such as feathers, twigs, raffia, stones, leaves, or other found items
- Oak tag, cut in 3" x 4" rectangles
- Paper towels
- Recycled 1-liter or larger, clear plastic bottles
- Recycled newspaper
- Plastic coffee stirrers or chenille stems
- Water containers

Tips
Ask parent and student volunteers to recycle liter-size clear plastic bottles. Cut off the bottom 4 inches with scissors or a utility knife. Prepare one container for each student. Volunteers also can cut oak tag rectangles as well as cardboard shapes that are slightly greater than the circumference of the bottle openings.
Cover the painting area with newspaper.

Resources
Living Jewels by Poul Beckmann
Old Cricket by Lisa Wheeler
The Very Clumsy Click Beetle by Eric Carle
The Very Quiet Cricket by Eric Carle

Visual Arts Standard 2
Reflecting upon and assessing the characteristics and merits of their work and the work of others.

Science Content Standard
Life Science
The characteristics of organisms

Unifying Concept & Process–Science As Inquiry
Evidence, models, and explanations
Abilities to do scientific inquiry

Objective
Students explore entomology, and then use their imaginations to create an insect model that is contained inside an enclosed environment.

Teacher Preparation
Classroom Teacher: Collect and display close-up photographs of insects on one half of a bulletin board and various types of natural environments where insects live on the other half. Have push pins and yarn available for students to match the two.

Art Teacher: Collect and display human-made habitats in which insects are typically contained for study or observation, such as simple cages, terrariums, ant farms, or other closed containers. Include mounted insects as well; show live insects if possible.

Discussion Starters
Classroom Teacher: Ask students to study the bulletin board and use the yarn to connect the insects to their habitats. Discuss the accuracy of the matches and list attributes that make a habitat a healthy place for insects to thrive.

Art Teacher: Ask students to recall the facts they listed that link insects to their natural habitats. Show and discuss artifacts or models that contain insects. Discuss new designs that could be created inside a bottle, based on observation of insects through a magnifying glass and knowledge about their activities.

Process
Create an Insect
1. Carefully observe insects with a magnifying glass. Study their shapes, colors, textures, and patterns. Look at Eric Carle's whimsical illustrations for inspiration.
2. Fold oak tag in half. Cut into the fold to create unusual and symmetric wings. Color the wings using Overwriters markers. Use the "under colors" first, then decorate the wings in elaborate patterns with the "over colors."
3. Shape Model Magic to create an insect body. Make sure it will fit in the bottle. Place wings over the body. Apply additional Model Magic to the wings' center to attach them to the insect body.
4. Embed cut chenille stems or plastic coffee stirrers into the insect for features. Use modeling tools to create texture. Air-dry the insect overnight.
5. Paint the insect with watercolors. Air-dry the paint.
6. Decorate your insect with glitter glue, feathers, or other craft materials. Air-dry the glue.

Design a Natural Habitat
1. Shape Model Magic to create a display base for your insect. Insert raffia, twigs, or other natural elements into the base. Air-dry it overnight.
2. Watercolor the modeled base to reflect your imagined environment. Air-dry the paint.
3. Glue the base to cardboard. Glue insect into the habitat. Air-dry the glue.
4. Place the plastic bottle over the model. Apply glue around the circumference of the bottle. Roll and then wrap a coil of Model Magic over and around the glue to seal the bottle to the cardboard. Air-dry the art.
5. Write a paragraph describing the model insect and its habitat.

Assessment
Display student insect models in their enclosed environments. Ask students to analyze and then match insect models and environments to descriptive writings. Summarize learning.

 Artwork by students from
Madison Elementary School, Colorado
Springs, Colorado.
Teacher: Judy Curtis

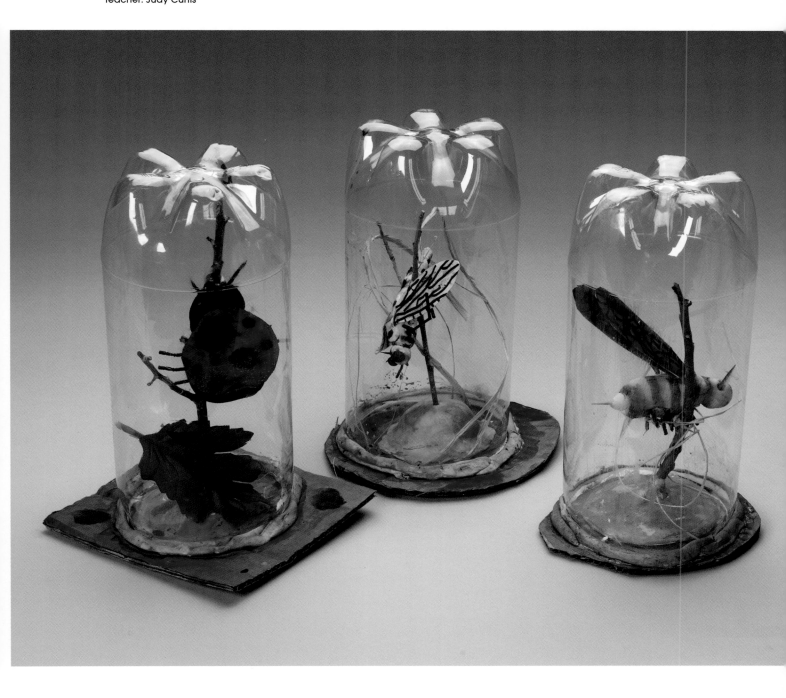

Background Information

 A biosphere is a zone where life naturally occurs. Earth's biosphere extends from the deep crust to the lower atmosphere. Insects account for more than 50% of all animal and plant life on Earth. For the most part, insects lead their lives quietly and go about their business unnoticed.

 Beetles are just one species of insect. "Evolving over 250 million years, shaping themselves to fit every conceivable climate and landscape on Earth, the order of Coleoptera–the beetles–has developed a phantasmagorical diversity of shapes and sizes, colors, patterns and textures," according to Poul Beckman in *Living Jewels*. More than a million species of every shape and form have been identified and several times that number remain unnamed.

Who Counts on Constellations?

Grade Level
5-6

Classroom Time
Two or three 40-min. periods

Materials/Tools
- Black craft paper, cut in to 3' x 6' sheets
- Crayola® Artista II® Tempera Paint
- Crayola Gel FX Marker Classpack®
- Crayola Paint Brushes
- Crayola Scissors
- Paper plates to use as paint palettes
- Paper towels
- Pencils
- Recycled newspaper
- Sponges
- Water containers

Tips
Invite a parent volunteer to help cut major star openings with a utility knife. Place cardboard under the mural. Push a pencil point through the mural paper where minor star holes are marked. Use inexpensive paper plates as paint palettes. Cover the painting area with newspaper.

Resources
Constellations of the Night Sky by Bruce LaFontaine
Find the Constellations by H.A. Rey, Revised Edition
The Stars - A New Way To See Them by H.A. Rey

Objective
Students recognize, graph, design, and paint constellation-map murals that accurately reflect local constellations observed in the night sky, as revealed through personal observation and research.

Teacher Preparation
Classroom Teacher: Attract student interest by displaying a picture or drawing of a constellation a couple of days before introducing the lesson. Use constellations aligned to the local night sky at the time. Explain that a constellation is an arbitrary configuration of stars, usually named after an object, animal, or mythological being that its outline suggests.

Art Teacher: Research and create a display of cosmological maps by Vincenzo Coronelli with details of specific constellations. Cut the mural paper. Create and display a sample mural.

Discussion Starters
Classroom Teacher: "What animals, objects, and beings have you seen in constellations? Do you think stars really outline these beings? How many of you have to stretch your imaginations to see the characters? Based on what you know about the placement of stars in constellations, why can you count on the constellations to tell you what you are looking at?"

Art Teacher: "In class you learned that stars in constellations seem to outline objects, animals, and beings. Based on your knowledge, let's work in teams to re-create night skies that reveal a real constellation."

Process
1. Break into teams of 4 to 6 students to research, design, and then draw a real constellation in the night sky. Use Gel FX markers on black mural paper. Mark minor stars with small circles and major stars with large circles.
2. Paint the night sky, except for the stars you drew, with tempera paint and brushes and/or sponges. Air-dry the mural.
3. **Let an adult cut** out the major star openings (see Tips) and press a pencil point through the minor stars.
4. Use the markers to add celestial bodies such as the Milky Way, moons, planets, and suns.
5. Tape the completed mural to a classroom window to reveal the major and minor stars represented in the constellations.

Assessment
Summarize learning. Before class, tape murals to windows. Remove all other sources of light. Invite students into the room. Challenge them to identify mural constellations based only on the major and minor starlight they observe. Turn on the lights to check if the constellations were correctly identified.

Visual Arts Standard 3
Choosing and evaluating a range of subject matter, symbols, and ideas.

Science Content Standard
Earth and Space Science
Earth in the solar system

Unifying Concept & Process–Science As Inquiry
Evidence, models, and explanations
Understanding scientific inquiry

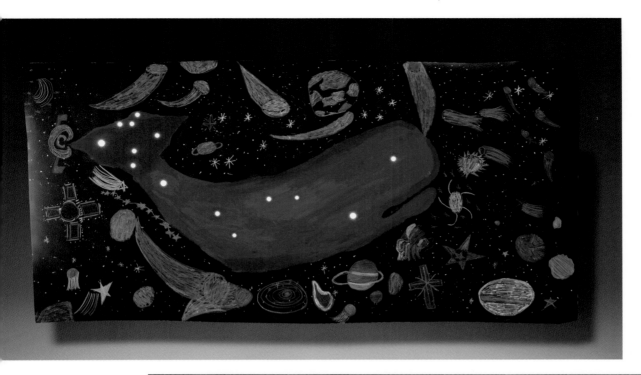

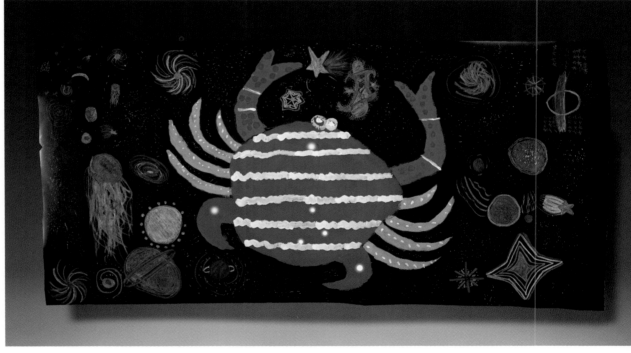

Artwork by students from
Chamberlin Elementary School, Colorado
Springs, Colorado.
Teacher: Patricia McKenna

Background Information

Vincenzo Coronelli was born in 1650 and died in 1718. He was Italy's most prolific globe maker, designing hundreds of maps and globes as large as 60 feet in circumference. Coronelli produced imaginative Baroque constellations similar to the ceilings of ornate 17th-century churches on his globes. He created the awe-inspiring *Orbis Coelestis Typus (Image of the Celestial World)* for France's King Louis XIV. The wedge-shaped gores contain mythological figures, fantasy, and information.

In the celestial map that Coronelli created of Scorpio (the scorpion), he shows Scorpio stinging Orion (the hunter) and causing his death.

On the ceiling of New York's Grand Central Terminal, visitors can observe a unique mural that contains images of constellations. It appears in reverse, as if the constellations were observed by beings from above.

How Can You Contribute to a Healthy Ecology?

Grade Level
5-6

Classroom Time
Two or three 40-min. periods

Materials/Tools
- Crayola® Erasable or Regular Colored Pencils
- Crayola Fine Line Marker
- Crayola Overwriters® Marker Classpack®
- White drawing paper

Tip
Ask parent volunteers to help collect, clean, and cut scrap lumber into blocks that students will use to visualize, assemble, and draw three-dimensional forms.

Resources
Frank Gehry by Jason Miller
Frank O. Gehry Outside In by Jan Greenberg & Sandra Jordan
Metropolis: Ten Cities–Ten Centuries by Albert Lorenz with Joy Schleh
Tall Buildings from The Museum of Modern Art
The Chelsea House Library of Biography Frank Lloyd Wright by Yona Zeldis McDonough

Visual Arts Standard 6
Making connections between visual arts and other disciplines.

Science Content Standard
Science in Personal and Social Perspectives
Populations, resources, and environments

Unifying Concept & Process–Science As Inquiry
Systems, order, and organizations Abilities necessary to do scientific inquiry

Objective
Students think about, visualize, and then create an urban architectural design that incorporates features to ecologically sustain life on Earth.

Teacher Preparation
Classroom Teacher: Create a bulletin board with a title such as "What Does Urban Architecture Look Like?". Ask students to help collect and display photographs of various urban landscapes that include buildings, parks, transportation systems, gardens, industrial zones, and more.

Art Teacher: Contact your local city planners and ask if you can borrow blueprints of buildings that have been erected in your community. Invite residential, commercial, and landscape architects who live in your community to talk with your students about design planning. Ask architects to bring examples of their work in print or model form.

Discussion Starters
Classroom Teacher: Invite students to discuss the bulletin board. Tell students that ecology is the branch of biology that deals with the relationship of living things to their environment. Ask students to write a list of everything they see in the photos that links structures and other elements to the environment. Encourage students to identify reasons why the designs were good (or unwise) ecological choices.

Art Teacher: Challenge students to think about, visualize, and then draw an urban environment. Encourage them to include buildings, parks, transportation systems, industrial parks, and more as part of healthy design solutions that will contribute positively to the world's ecology. Suggest that they consider that plant, animal, and human life must co-exist in their plans.

Process
1. Think about and then visualize what elements are part of an ecologically sound urban design.
2. Sketch buildings, living areas, parks, transportation systems, gardens, industrial zones, and other community spaces using erasable colored pencils and white drawing paper.
3. Emphasize sections of your design by filling shapes with Overwriters "under colors." Create lines, shapes, and textures with "over colors." Add details with fine line markers.
4. Prepare a legend that identifies the components of your design using colored pencils.

Assessment
Ask students to identify the ecological features that are illustrated in their urban designs. Encourage classmates to check each other's art to identify one or more environmentally friendly solutions illustrated in the work that will contribute to a healthy environment. Summarize learning.

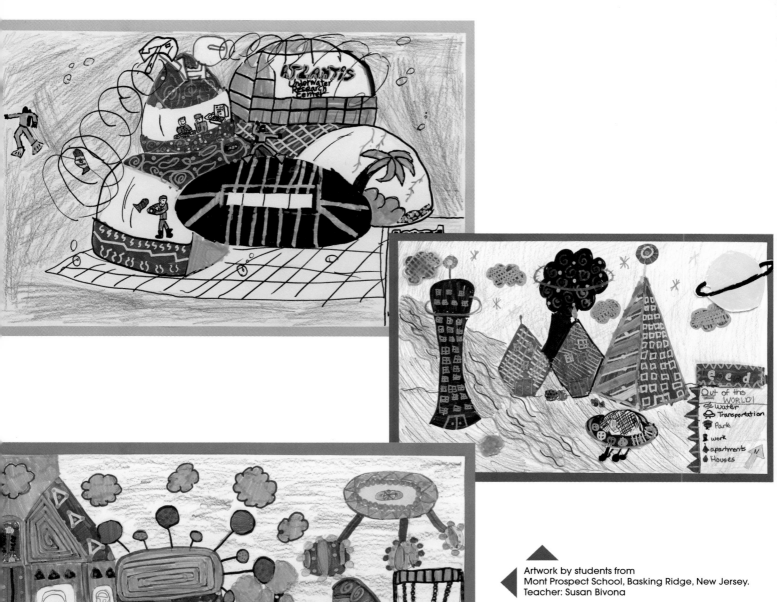

Artwork by students from
Mont Prospect School, Basking Ridge, New Jersey.
Teacher: Susan Bivona

Background Information

People have lived together in cities for thousands of years. Many cities are designed so they are a few stories high and stretch outward in unwilding sprawl for miles. One designer's solution to this urban sprawl is to design communities so they "implode" rather than "explode" on open, green space. In the 1960's Paolo Soleri combined the design of cities with the concept of ecology. His term "archology" proposes a highly integrated and compact three-dimensional urban form that joins architecture and ecology and focuses on stopping urban sprawl. His city designs encourage and fuse conservation of land, energy and resources.

How Can Your Design Help Save Endangered Species?

Grade Level
5-6

Classroom Time
Two or three 40-min. periods

Materials/Tools
- Colored/black construction paper
- Crayola® Gel FX Marker Classpack®
- Crayola Glitter Glue Classpack
- Crayola Paint Brushes
- Crayola Watercolor Colored Pencils
- Paper towels
- Recycled newspaper
- Water containers
- White drawing paper

Tips
Draw with dry watercolor pencils and then apply water washes over the drawing to generate painterly effects. Repeat the process to create layered effects. Cover the art area with newspaper.

Resources
Beaks by Sneed B. Collard III
Our Wet World by Sneed B. Collard III
The Forest in the Clouds by Sneed B. Collard III
The Living Rain Forest–An Animal Alphabet by Paul Kratter
Winged Migration–The Junior Edition by Stephane Durand and Guillaume Poyet

Visual Arts Standard 5
Reflecting upon and assessing the characteristics and merits of their work and the work of others.

Science Content Standard
Science & Technology
Abilities to distinguish between natural objects and objects made by humans.

Unifying Concept & Process–Science As Inquiry
Evolution and equilibrium
Understanding about scientific inquiry

Objective
Students use knowledge about endangered species and their habitats to design promotional literature that communicates, through text and illustrations, how people might take action to help save endangered species.

Teacher Preparation
Classroom Teacher: With students, research, collect, and display photographs of insects, plants, and animals that are on the extreme endangered species list. Design a chart with two columns and about 15 rows. Label one column "Endangered Species" and the second column "Solutions to Avoid Extinction." Use the chart to begin a class discussion around the topic.

Art Teacher: Design a display of various advertising and design formats such as tri-folds, brochures, mini-booklets, pamphlets, and one-page flyers. Demonstrate step-by-step watercolor pencil drawing and painting techniques that best illustrate earth, sea, sky, and animals. Include dry brush, wet-on-wet, and dry-on-wet techniques.

Discussion Starters
Classroom Teacher: Discuss what the word *endangered* means. "Endangered species are plants and animals that are in danger of becoming extinct. *Extinct* means they will no longer live on Earth." Invite children to research the most critically endangered plants and animals. Invite them to add species to the chart if they can offer practical solutions that will help avoid extinction of the animal.

Art Teacher: Ask students to reflect on their knowledge about endangered species. Invite them to design a piece of literature whose text and illustrations call out solutions that help keep endangered species from becoming extinct. Design formats can vary.

Process
1. Select a species listed on the extreme endangered list. Your charge is to reverse a grave situation that exists for an insect, plant, or animal.
2. Visualize and then create a promotional brochure that addresses the issues using watercolor pencils. Consider various design formats, text, and illustrations. Include three or more watercolor drawing and painting techniques in your design format.
3. Clearly articulate and detail your solution so that the literature becomes an effective public relations tool and captures the audience's attention. Analyze your work for its attention-getting effectiveness and attributes.

Assessment
Display all designs. Invite students to rank which designs most effectively communicate and address the cause, and then list reasons that support each student's choice. Arrange to exhibit the artwork at a local bank or community center. Check to see that three or more watercolor pencil techniques were used to create the art. Summarize learning.

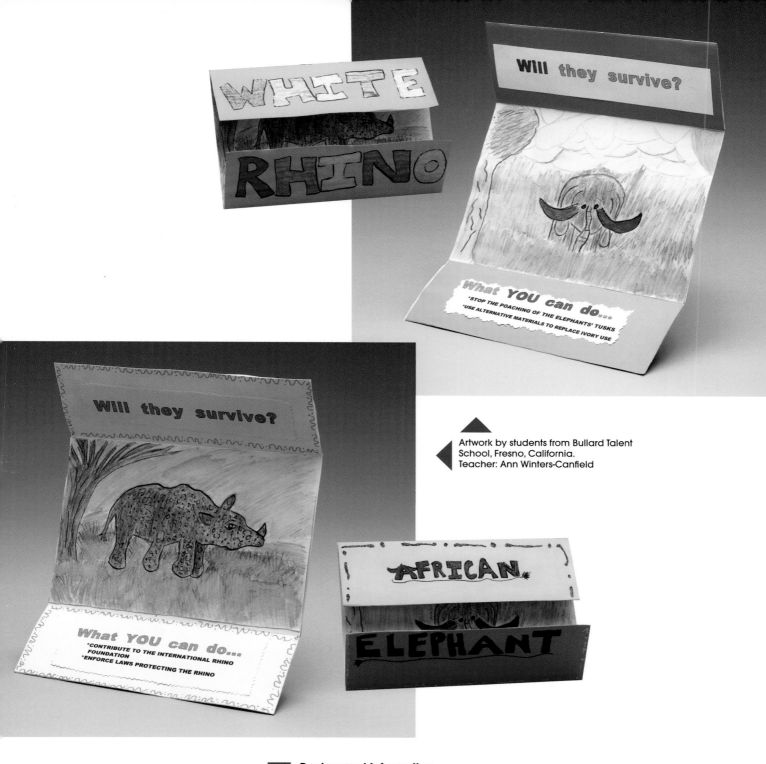

Artwork by students from Bullard Talent School, Fresno, California.
Teacher: Ann Winters-Canfield

Background Information

Every living being contributes to the balance of life on this planet. An estimated 74 species of plants and animals become extinct every day, critically challenging the balance the Earth struggles to maintain. Actions of humans are mostly to blame for this dilemma, and it is also our actions that can begin the movement back towards ecological health.

Fewer than 1,000 pandas remain in the mountainous bamboo forests of Southwestern China. The chances of this animal rebounding are diminished by factors such as habitat destruction, poaching, and the panda's low reproductive capacity.

Sea turtles are able to migrate hundreds and sometimes thousands of miles, traveling from their feeding ground to their nesting beach, which is usually the same beach on which they were born. Out of seven species of sea turtles, four are classified as endangered: the green turtle, the leatherback, the hawksbill, and Kemp's Ridley.

Whose Bones Identify
Terrible Lizards?

See lesson on page 10

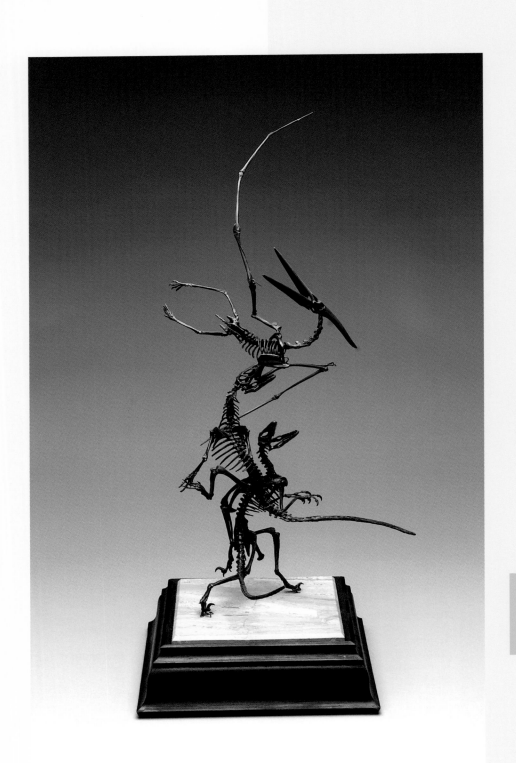

Vortex Pteranodon and Dienonychus
By Nelson Maniscalco
2004
Bronze, marble, and wood
27" x 10"
Private Collection

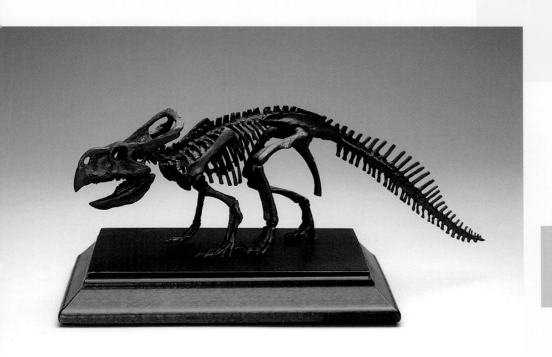

Quiet Walk – Protoceratops
By Nelson Maniscalco
2004
Bronze, marble, and wood
4" x 9"
Private Collection

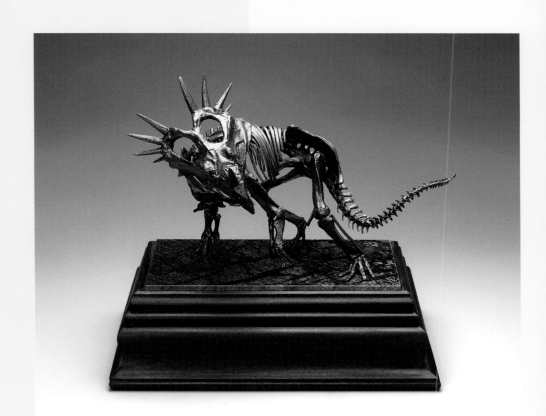

Poised for Battle - Styracosaurus
By Nelson Maniscalco
2004
Silicone bronze, marble, and wood
16 ½" x 16"
Private Collection

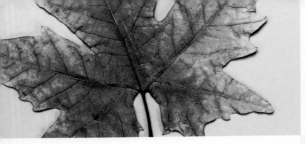

Whose Bones Identify Terrible Lizards?

See lesson on page 10

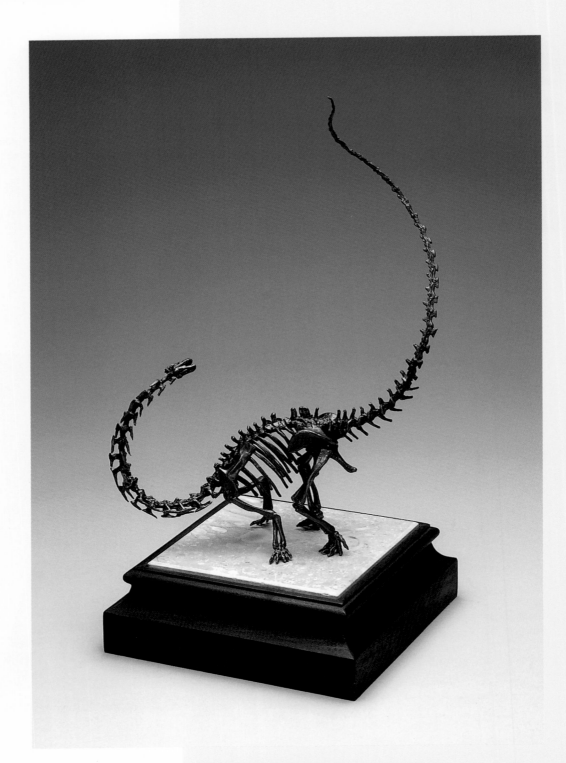

Trumpeting the Moment – Barasaurus
By Nelson Maniscalco
2004
Silicone bronze, marble, and wood
18" x 7"
Private Collection

What Clues Do Leaves Leave Behind?

See lesson on page 12

The Equatorial Jungle
Artist: Henri Rousseau
Chester Dale Collection
Image ©2005
Board of Trustees
National Gallery of Art, Washington, 1909
Oil on canvas
1.406 x 1.295 (55 x 64)

What Clues Do Leaves Leave Behind?

See lesson on page 12

Tropical Forest with Monkeys
Artist: Henri Rousseau
John Hay Whitney Collection,
Image ©2005
Board of Trustees
National Gallery of Art,
Washington, 1810
Oil on canvas
1.295 x 1.625 (51 x 64)

Birds Floating on Leaves
2004
By Chris Roberts Antieau
Fabric scraps collage, thread
14" x 40"
Manchester, Minnesota
Collection of the artist

Leaf Ornaments
1999
Artist Unknown
Gold-plated leaves
Beech leaf – 3 ½" x 4"
Red maple leaf – 3 ¾" x 4"
Maple leaf – 4 ½" x 6"
Pennsylvania
Private Collection

Leaf Design Mola
1995
Artist Unknown
Colored cotton fabric, thread
12" x 14"
Cuna Indians
San Blas Islands
Private Collection

Where Does the Tooth Fairy Take Lost Teeth?

See lesson on page 16

Decorative Ceramic Tile
1999
By Eisenhardt
White talc clay, underglazes
6" x 6" x ½"
Private Collection

Fedoskino Russian
Lacquer Box
"Kremlin Tower"
2003
Artist unknown
4 ¼" x 2 ⅛" x 1 ¼"
Painted lacquer
St. Petersburg, Russia
Private Collection

Fedoskino Russian
Lacquer Box
"Ykpauukq"
2002
By Pomuzel
Painted lacquer
2 ¾" x 4 ½" x 4"
St. Petersburg, Russia
Private Collection

Fedoskino Russian
Lacquer Box
"Frog Prince"
2003
Artist unknown
Lacquer, mother of
pearl, paint
1" x 2" x 2 ½"
St. Petersburg, Russia
Private Collection

How Will You Create a Phases-of-the-Moon Manga?

See lesson on page 20

Detail
The Story of King Solomon and Queen of Sheeba
2003
By Telawun
Oil on canvas
3' 4 ½" x 15 ½"
Ethiopia
Private Collection

Assorted Decorative Eggs
Private Collection

1) Russian Wood Egg
Carved and woven
low-relief dyed wood
2 ¾" x 2" x 2"

2) Ostrich Egg
5" x 5" x 6"
Natural egg shell

3) Painted Wood Egg
5" x 3 ½"
Wood, paint, gold leaf

4) Lomonosov Porcelain Egg
14-carat gold, blue glaze,
porcelain
4" x 3" x 3" w/o base

5) Wooden Egg
3" x 2 ½"
Curly burl maple wood

6) Russian Crystal Egg
Etched lead crystal
3" x 3" x 3 ¾"

7) Fabergé-style Egg
Enamel, rhinestones, gold
plate over base metal
2 ½" x 1 ¾" x 1 ¾"

8) Red Ware Scrafitto Egg
Red clay, yellow slip, glaze
3 ½" x 2 ½" x 2 ½"

9) Amber Egg
Cut and polished amber,
organic material
2 ½" x 1 ½" x 1 ½"

10) Pysanky Egg
Egg shell, dyes, shellac
2 ½" x 1 ½"

11) Pysanky Egg
Egg shell, dyes, shellac
2 ½" x 1 ½"

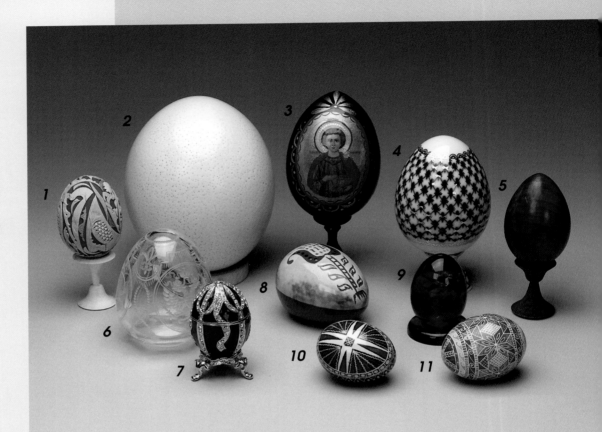

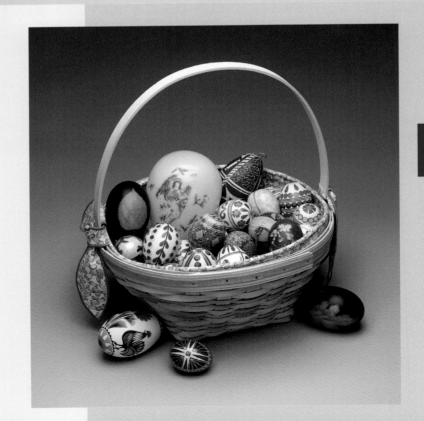

Longaberger Basket with Assorted Decorative Eggs
Various decorative eggs
14" x 14"

See lesson on page 24

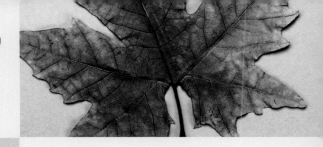

Trotting Horse Weather Vane
Circa 1800
Artist unknown
American (New England, possibly Connecticut)
Hammered copper, tin wash, gold leaf
30" x 48" x 3"
Allentown Art Museum, Purchase: The Gift of John and Fannie Saeger, 1973. (1973.03)

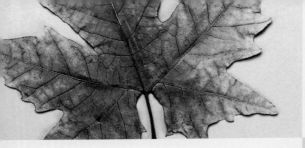

In What Biosphere Will Bugs Thrive?

See lesson on page 26

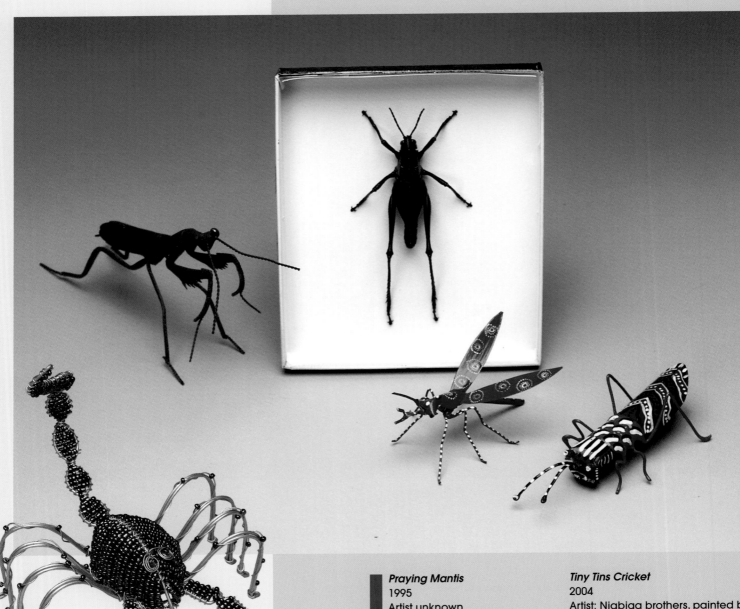

Beaded Scorpion
2004
Artist unknown
Aluminum wire, glass beads
8" x 4" x 5 ¼"
South Africa
Private Collection

Praying Mantis
1995
Artist unknown
Painted assembled metals
8 ½" x 2" x 3 ¾"
Pennsylvania
Private Collection

Lubber Grasshopper
2004
Insect specimen
Species - Romaka guttatall
Southern USA
Private Collection

Tiny Tins Cricket
2004
Artist: Njabjga brothers, painted by
Weya community
Painted and assembled tin
¾" x 4 ½" x 1 ³/₈'
Zimbabwe, Africa
Private Collection

Tiny Tins Red Fly
2004
Artist: Njabjga brothers, painted by
Weya community
Painted and assembled tin
3 ½" x 2 ¼" x 2 ¼"
Zimbabwe, Africa
Private Collection

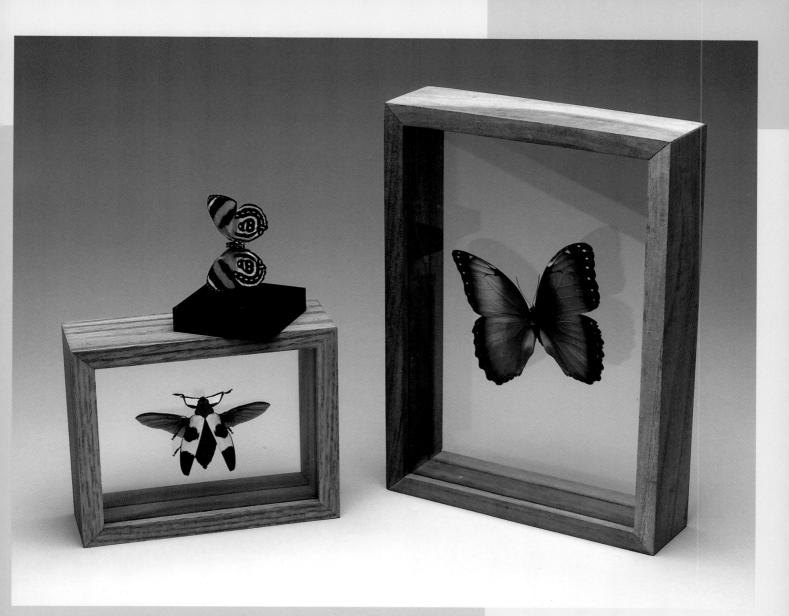

Red Orange Butterfly
2004
Insect specimen
2" x 1 ½" x ¹/₁₆"
South American Rainforest
Private Collection

Iridescent Blue, Red & White Beetle
2004
Species - Chrysochroa rugicollis
3 ¼" x 1 ¾" x ¾"
Malaysia
Private Collection

Iridescent Blue Butterfly
2004
Insect specimen
Species - Morpho peleides I.
4 ½" x 3 ½" x ¹/₁₆"
South America
Private Collection

Dragonfly Fossil
2002
5" x 5 ½" x ³/₁₆"
Private Collection

Who Counts on Constellations?

See lesson on page 28

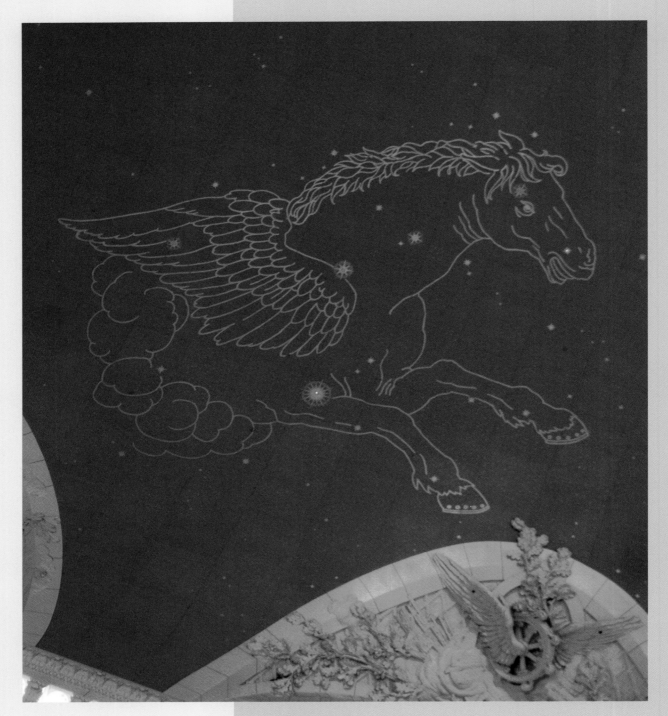

New York's Grand Central Terminal's Main Concourse Ceiling
Winter Sky Zodiac Constellation
By Paul Helleu of the Hewlett-Basing Studio
275' x 120' x 125'
Paint, 24-carat gold leaf
New York, New York
Photo by Ron DeLong